In the Beginning

COLORING CREATION
INSPIRATIONAL ADULT COLORING BOOK

ARTWORK BY
ERIN JONS

BroadStreet
PUBLISHING

BroadStreet Publishing Group LLC
Racine, Wisconsin, USA
Broadstreetpublishing.com

MAJESTIC EXPRESSIONS

In the Beginning: Coloring Creation
© 2015 by BroadStreet Publishing

ISBN 978-1-4245-5139-2

Primary artwork by Erin Jons with contributions from Ember Canada.

Cover design by Chris Garborg | garborgdesign.com
Compiled and edited by Michelle Winger | www.literallyprecise.com

Printed in the United States of America.

15 16 17 18 19 20 21 7 6 5 4 3 2 1

ABOUT THE ILLUSTRATOR

ERIN JONS is a self-taught artist who enjoys the intricacies of creativity. Her relationship with paper and ink began in 1998 as she drew, sketched, and doodled her way through the trials of high school lectures. This relationship has continued in the form of portraits, theatrical set design, and drawing countless coloring pages for her own children. She is humbled and delighted to see her art mingle with God's precious and powerful Word, and prays that time spent with each page will reveal a glimpse of the beauty of Jesus. Erin is happily married with five children in Northern Idaho.

INTRODUCTION

WHY ADULT COLORING BOOKS?

There is plenty of research that shows coloring to be an effective stress reducer. Maybe you picked up this book because you've heard the hype and you're curious. Perhaps you've been searching for a way to relax. Or, if you're like many others we've encountered, you've been looking for a good excuse to color since you grew up and coloring books were no longer an acceptable hobby. Over the years, you may have found yourself eager to babysit kids who were fond of coloring, or maybe you have children or grandchildren of your own that "need" your help filling in the pages of their coloring books.

Finally, you hold in your hands your very own adult coloring book. And you have every reason you need to sit down and color. You have entered a stress-free zone. There's no wrong way to do this. If you want the grass to be blue and the sky to be green, go right ahead. If you only want to color a portion of a picture, do it. Crayons? Coloring pencils? Markers? It's your choice. This is your book, and this is your time.

Let's take it a step further. While coloring may be a great distraction from all you have going on, the best way to find lasting peace is to spend time with your Creator. As you fill these intricately designed illustrations with the beauty of color, dwell on the richness of his Word, the faithfulness of his character, and the depth of his love for you.

> "I HAVE TOLD YOU THESE THINGS, SO THAT IN ME YOU MAY HAVE PEACE.
> IN THIS WORLD YOU WILL HAVE TROUBLE.
> BUT TAKE HEART! I HAVE OVERCOME THE WORLD."
> JOHN 16:33 NIV

Happy coloring!

HIDDEN SYMBOLS

We've probably all dreamed of finding hidden treasure at some time in our lives. There's something captivating about the search, especially if it comes with potential reward!

Hidden within these pages are symbols representing aspects of the Christian faith. See if you can find them all! Some may best be stumbled upon as you color.

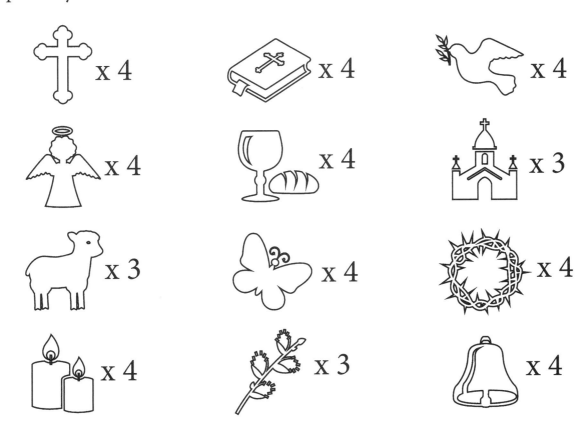

When you search for peace in God and in his Word, you will not be disappointed.

MAY THE LORD OF PEACE HIMSELF GIVE YOU PEACE
AT ALL TIMES IN EVERY WAY.
2 THESSALONIANS 3:16 ESV

For answers, please visit www.broadstreetpublishing.com.

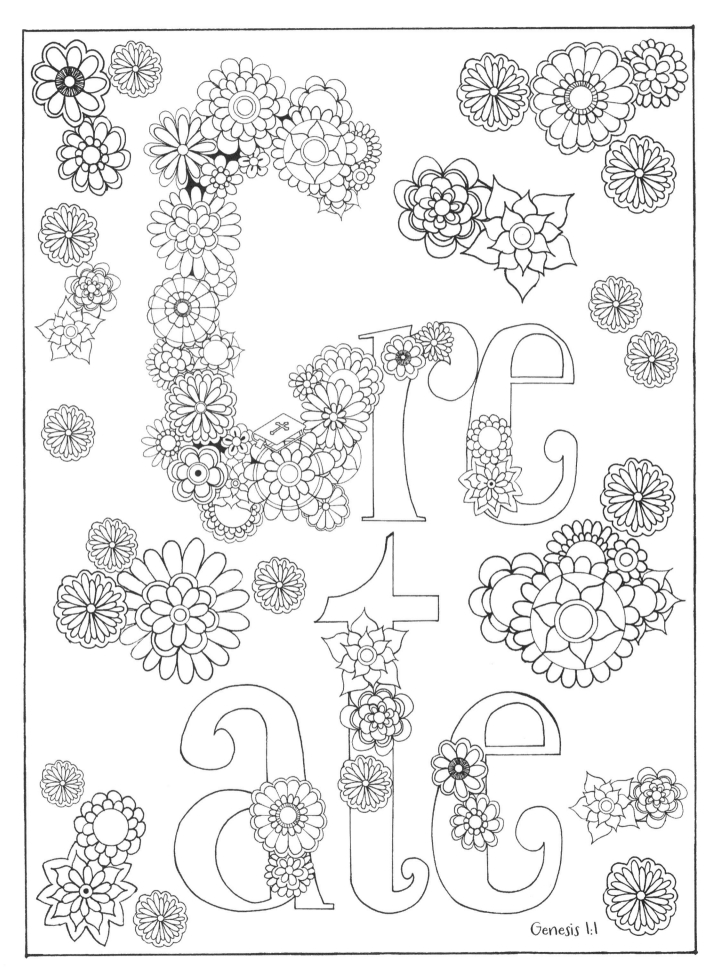

Create

Genesis 1:1

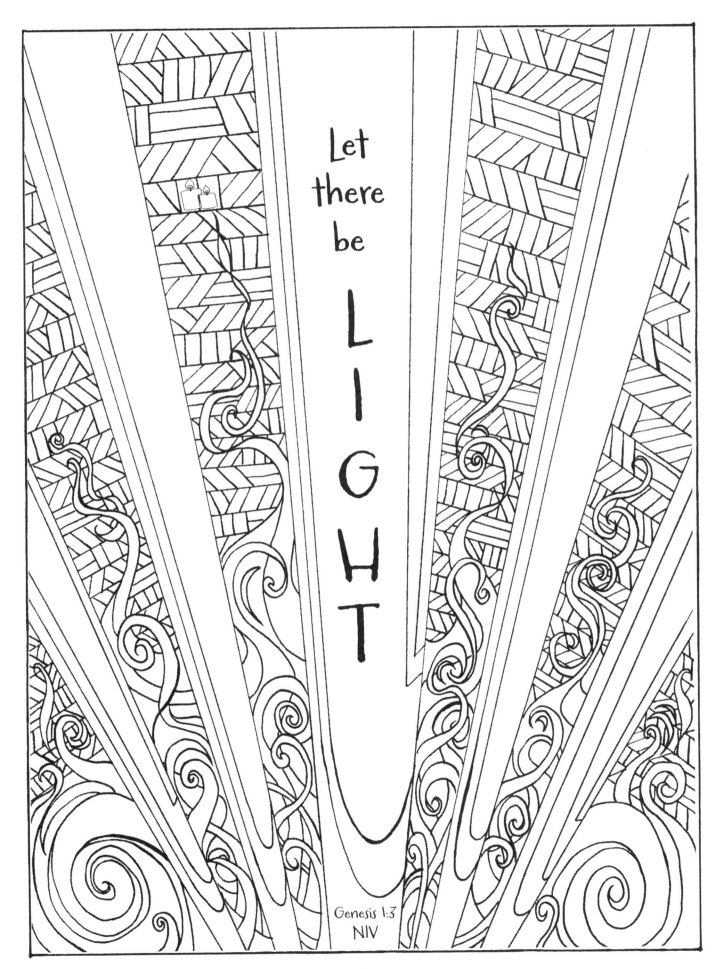

Let there be
LIGHT

Genesis 1:3
NIV

9

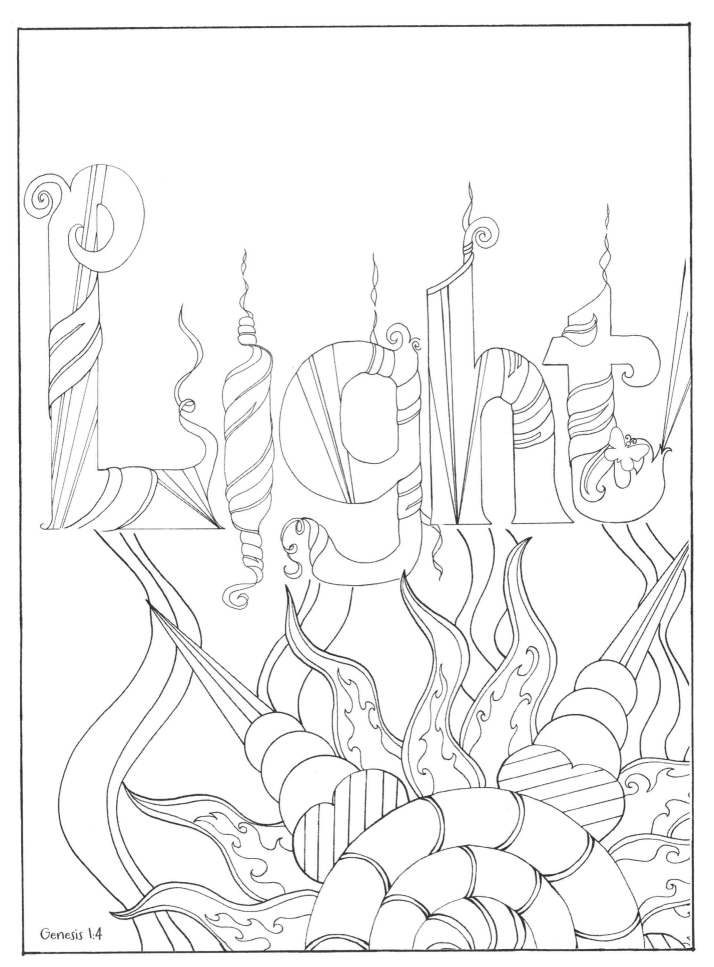

Genesis 1:4

11

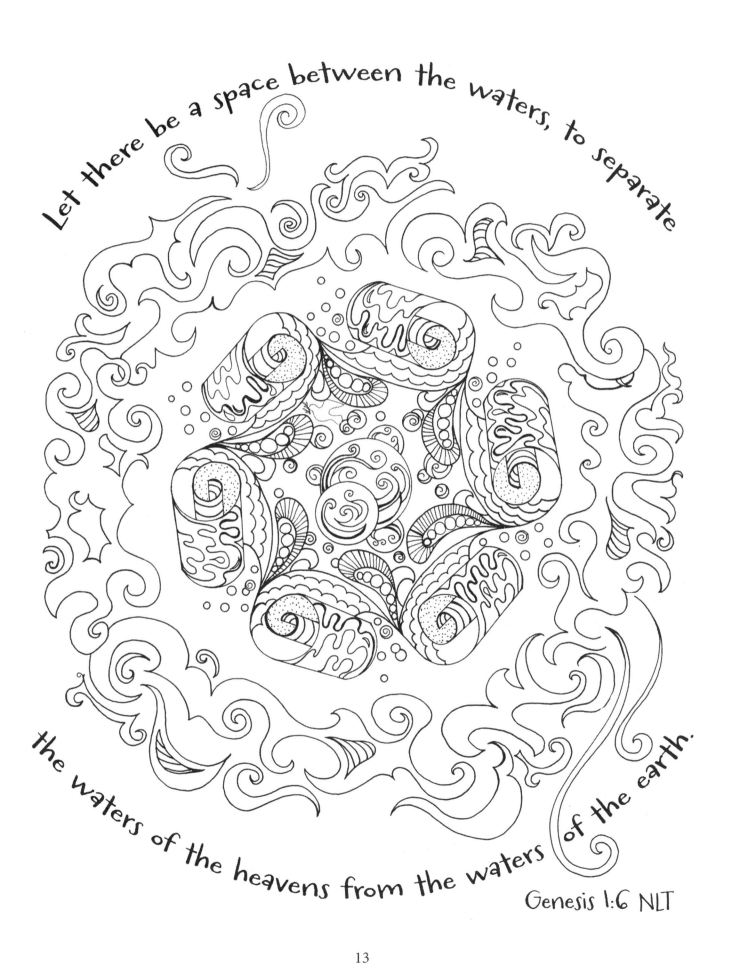

Let there be a space between the waters, to separate the waters of the heavens from the waters of the earth.

Genesis 1:6 NLT

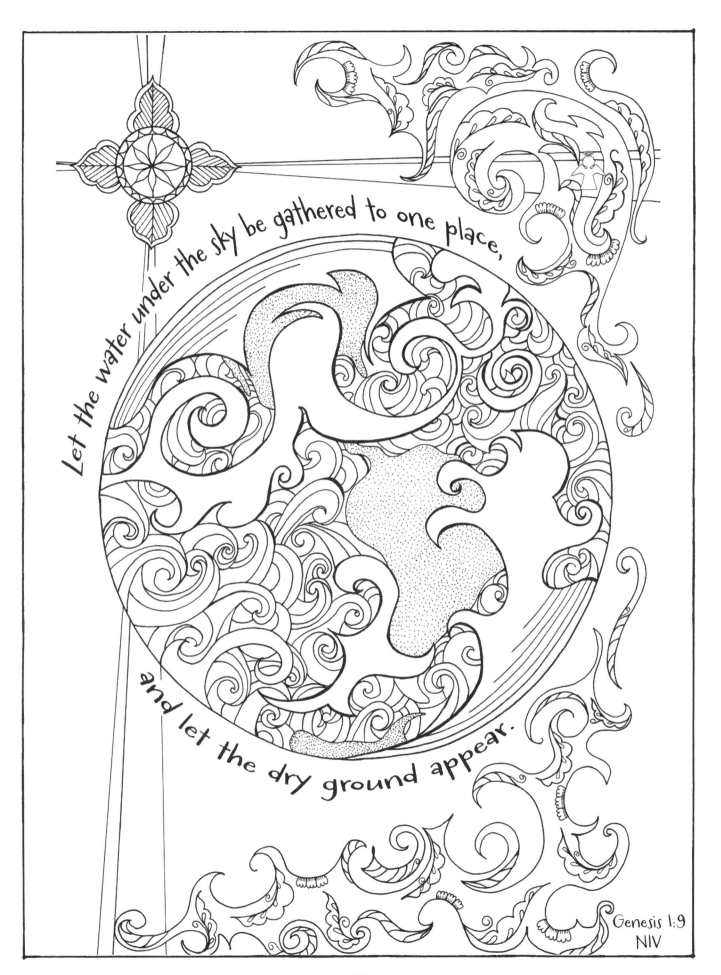

Let the water under the sky be gathered to one place, and let the dry ground appear.

Genesis 1:9
NIV

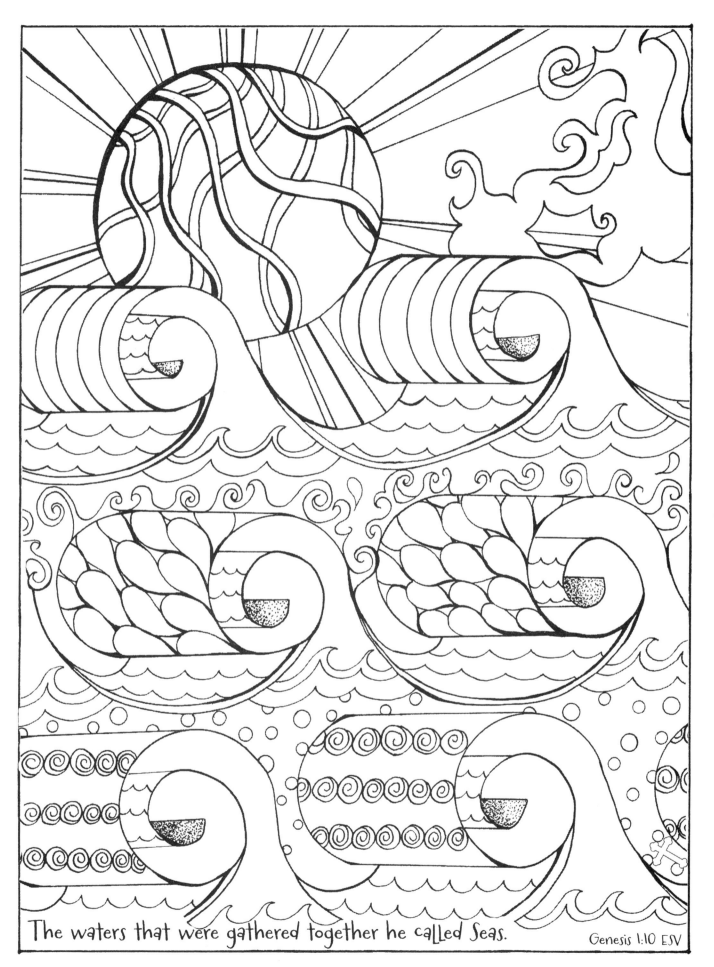

The waters that were gathered together he called Seas.

Genesis 1:10 ESV

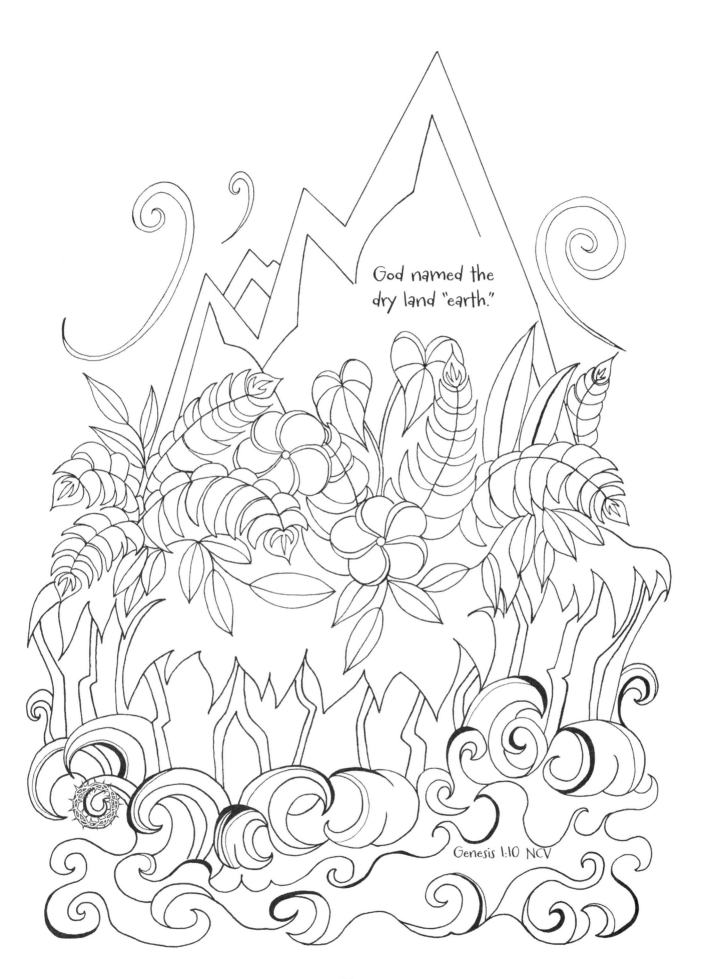

God named the
dry land "earth."

Genesis 1:10 NCV

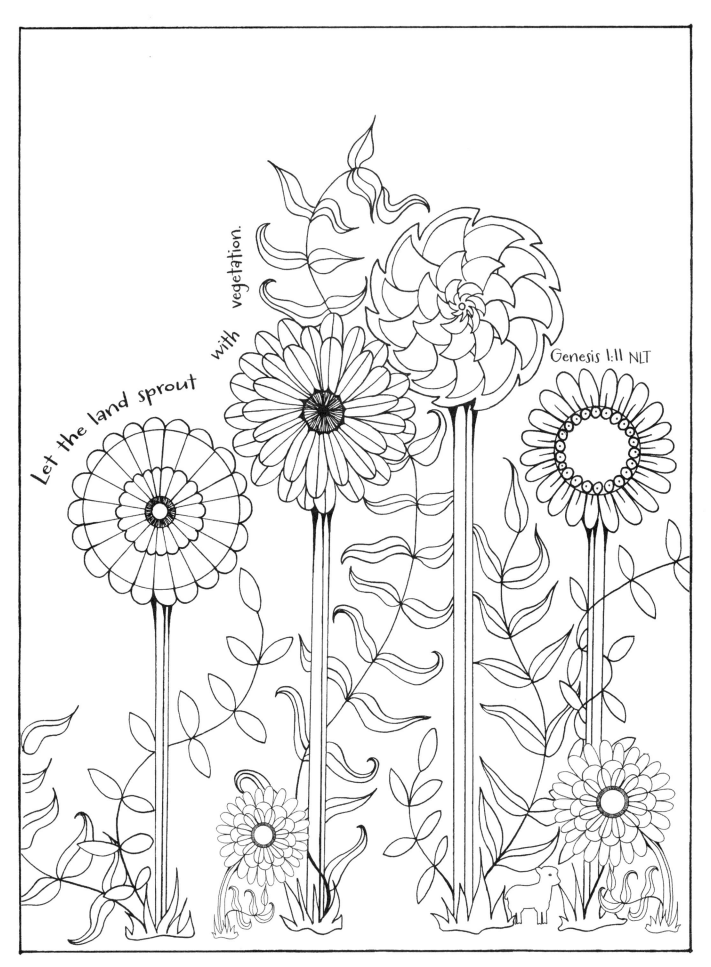

Let the land sprout with vegetation.

Genesis 1:11 NLT

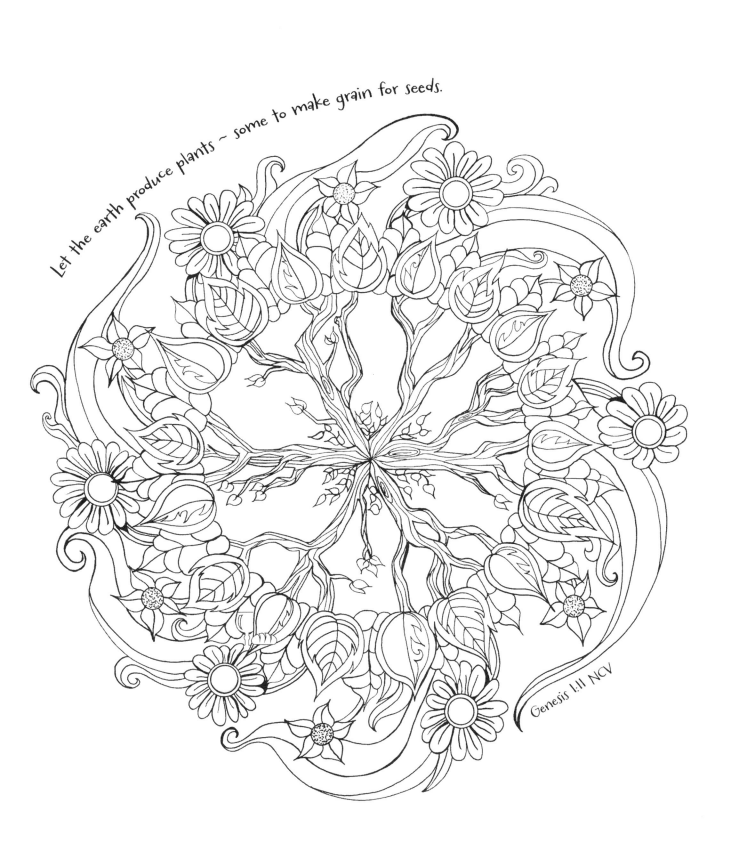

Let the earth produce plants ~ some to make grain for seeds.

Genesis 1:11 NCV

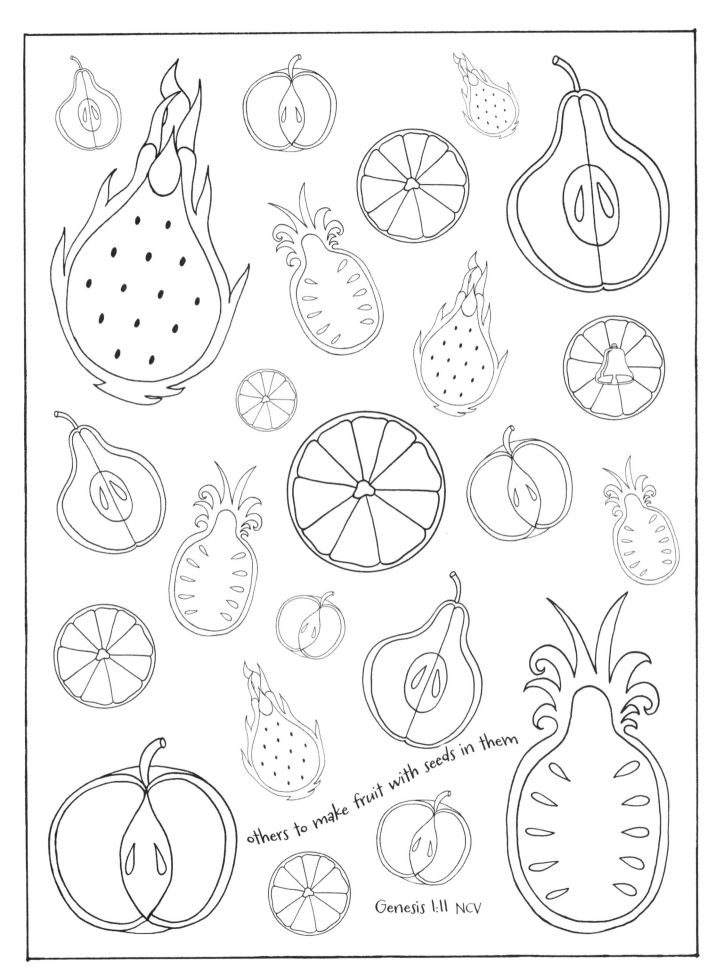

others to make fruit with seeds in them

Genesis 1:11 NCV

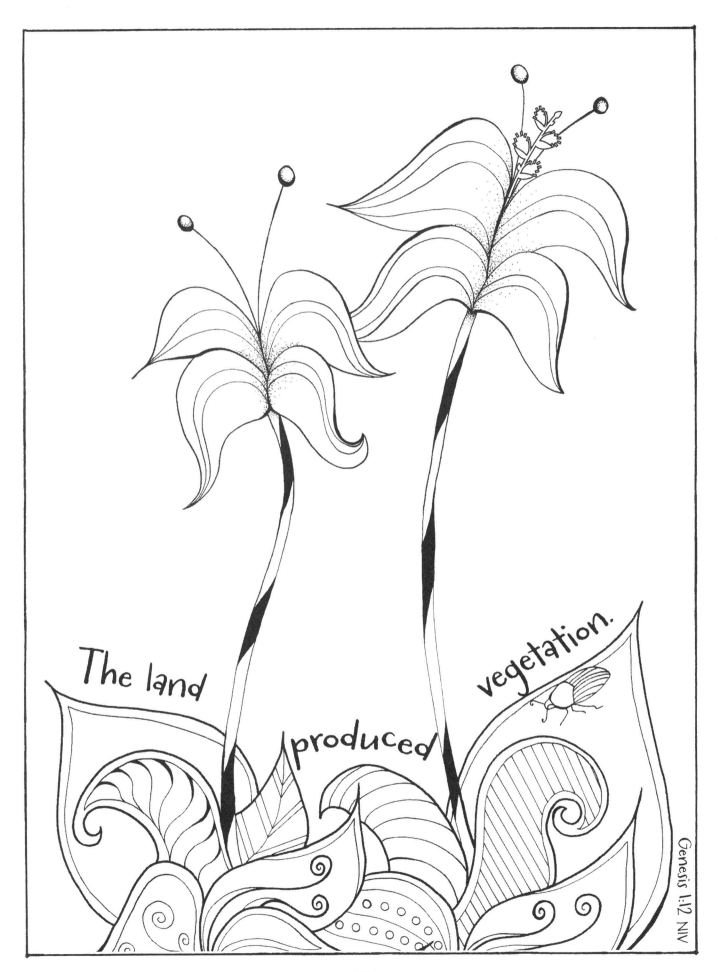

The land produced vegetation.

Genesis 1:12 NIV

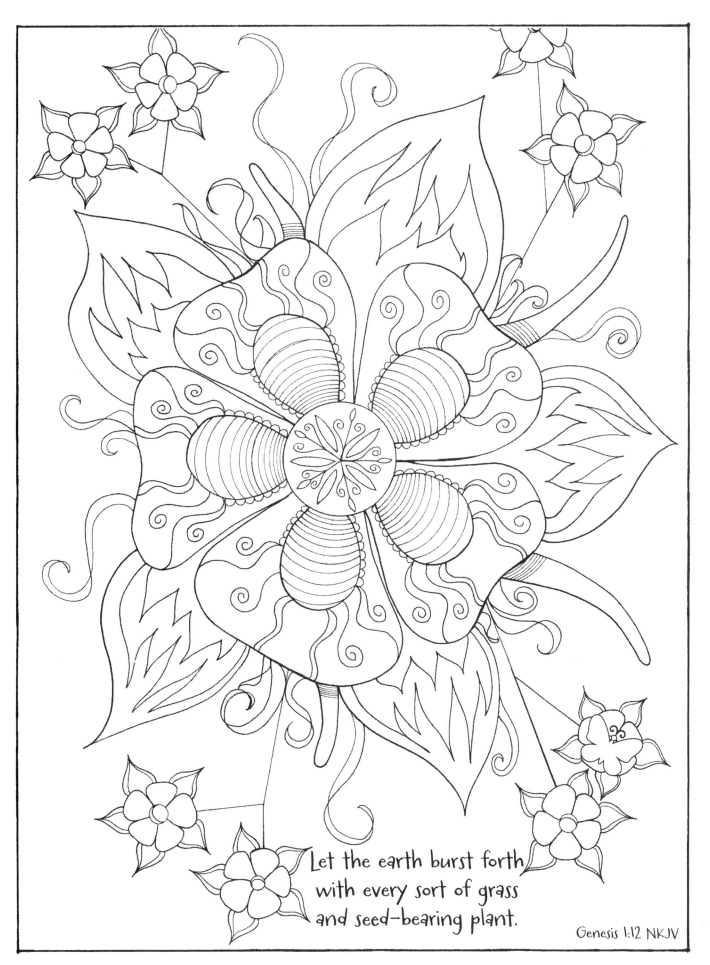

Let the earth burst forth with every sort of grass and seed-bearing plant.

Genesis 1:12 NKJV

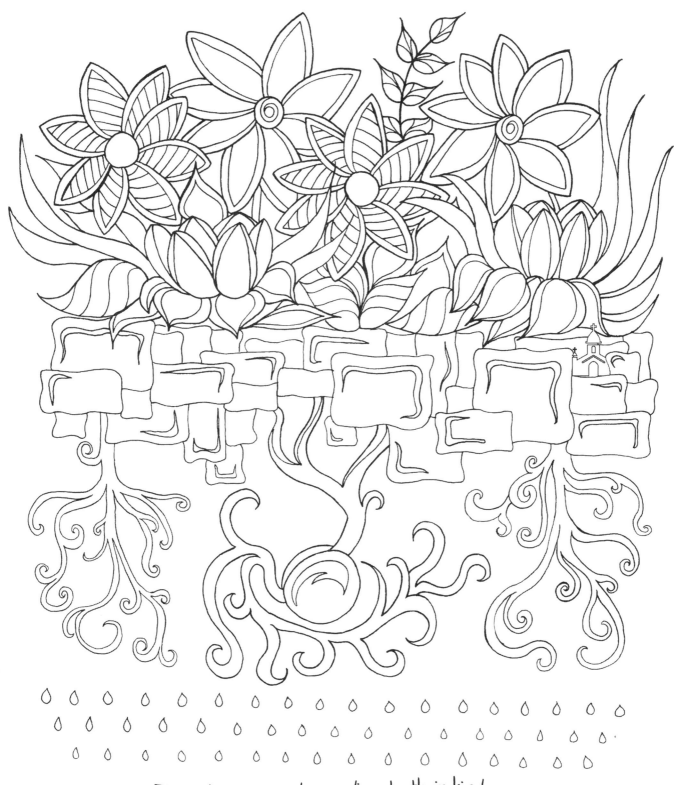

Plants bearing seed according to their kinds.

Genesis 1:12 NIV

And fruit trees with seeds inside the fruit, so that these seeds will produce the kinds of plants and fruits they come from.

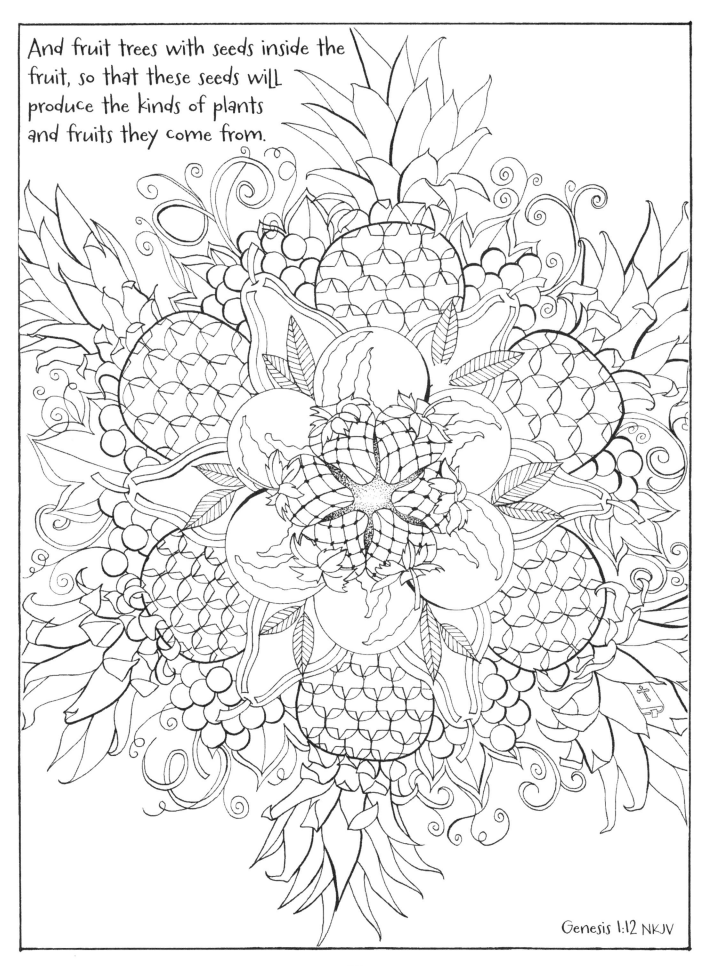

Genesis 1:12 NKJV

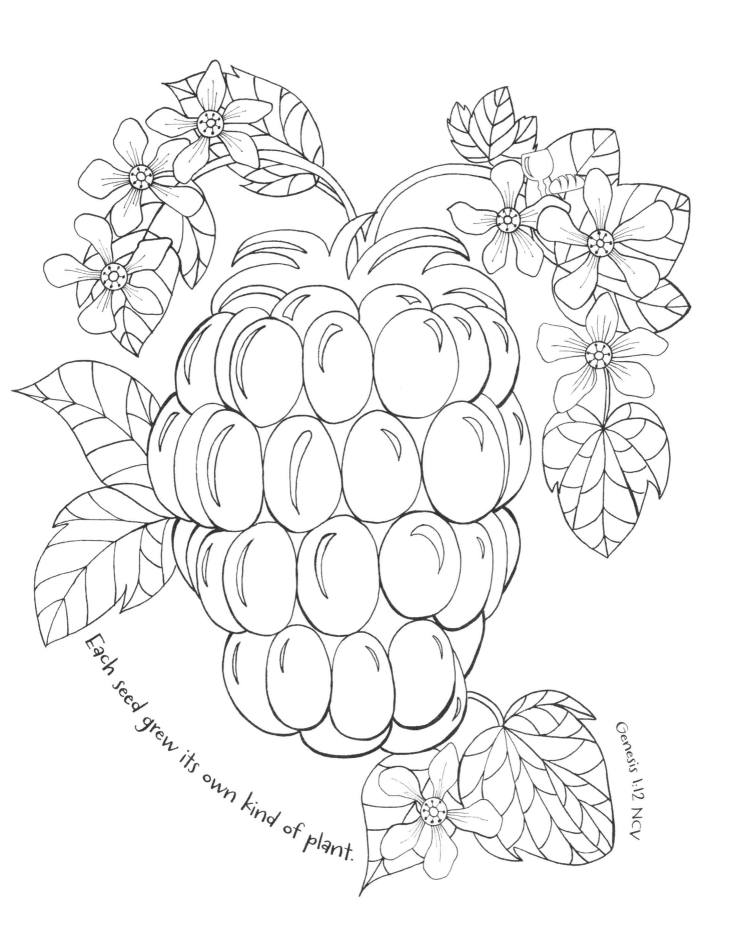

Each seed grew its own kind of plant.

Genesis 1:12 NCV

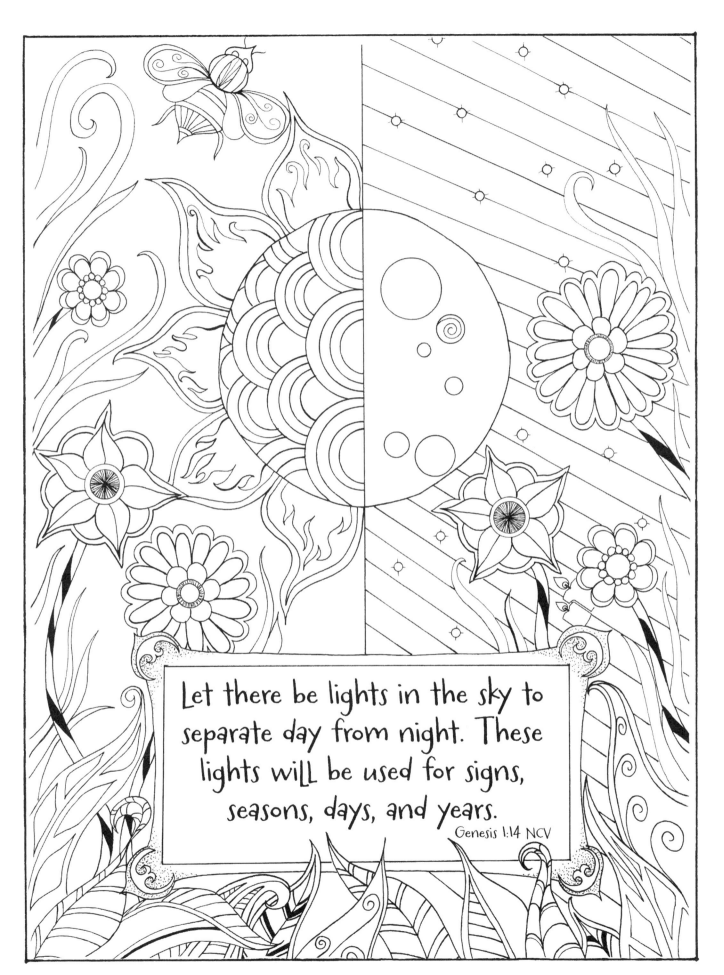

Let there be lights in the sky to separate day from night. These lights will be used for signs, seasons, days, and years.

Genesis 1:14 NCV

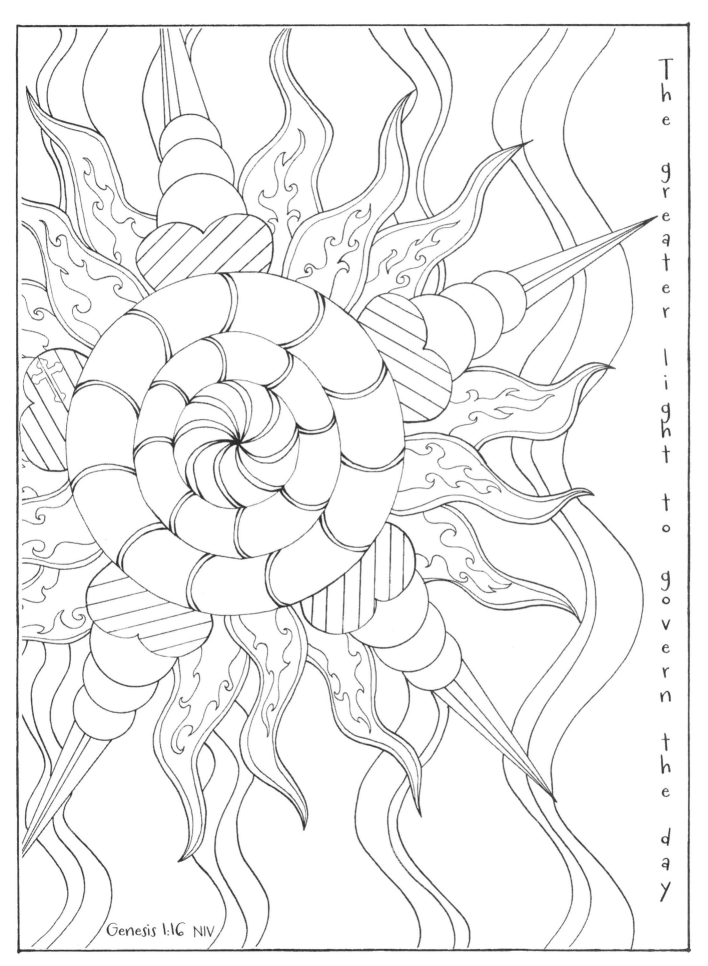

The greater light to govern the day

Genesis 1:16 NIV

The lesser light to govern the night

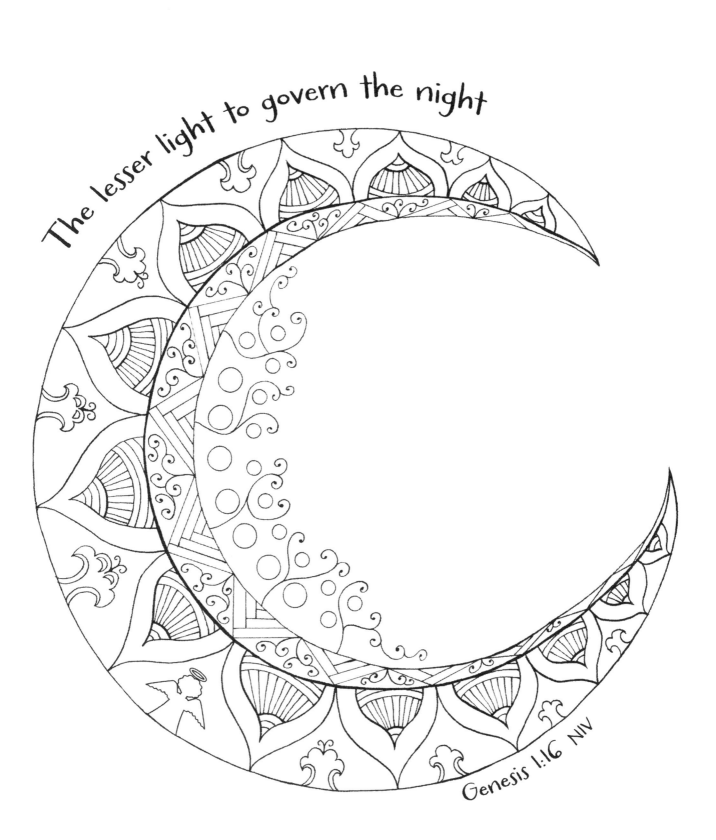

Genesis 1:16 NIV

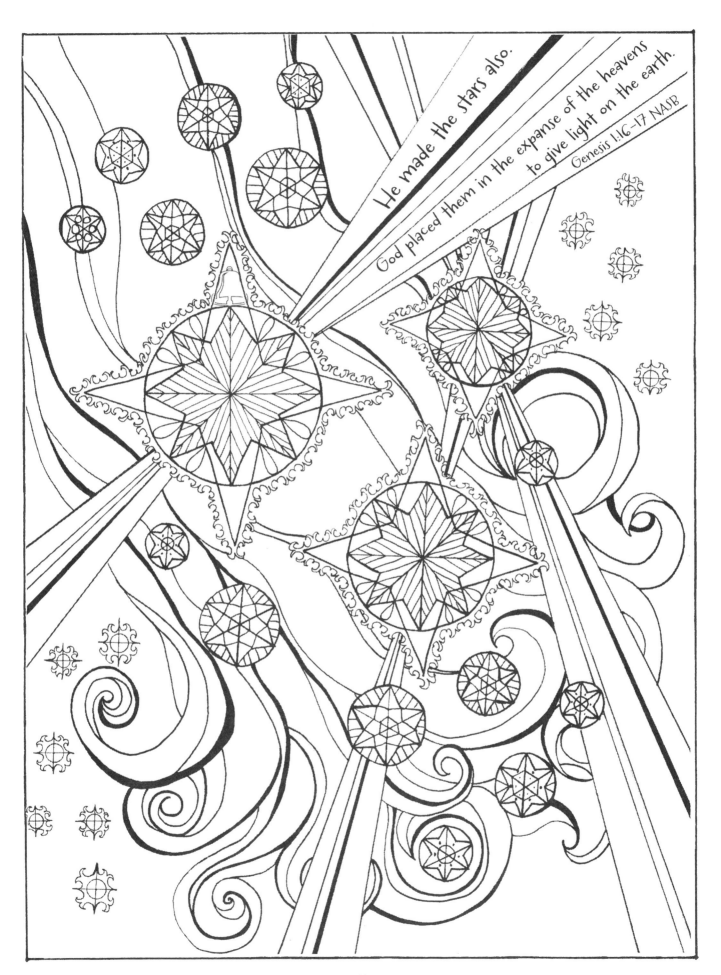

He made the stars also.

God placed them in the expanse of the heavens to give light on the earth.

Genesis 1:16–17 NASB

Let the waters teem

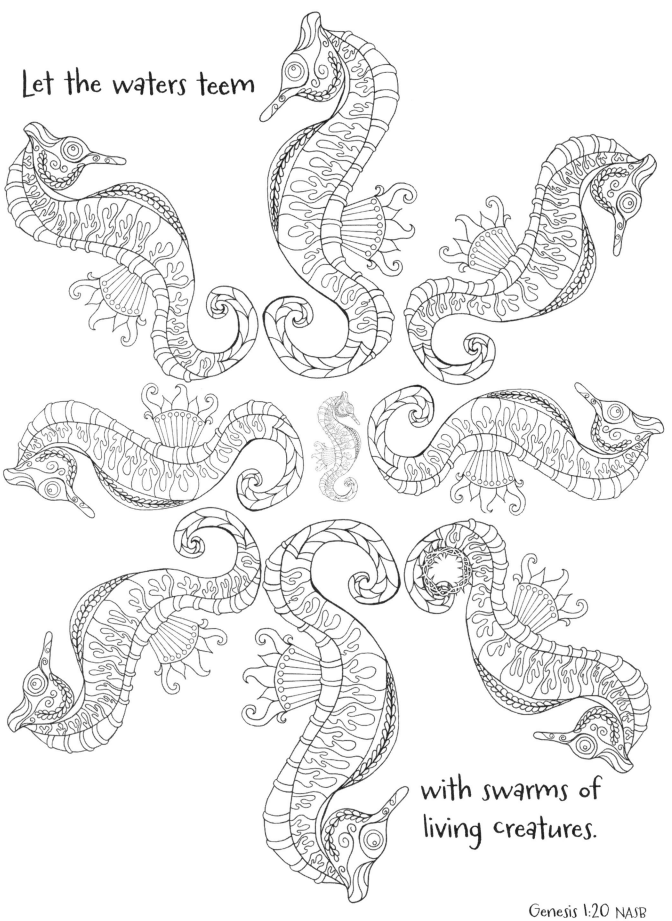

with swarms of
living creatures.

Genesis 1:20 NASB

45

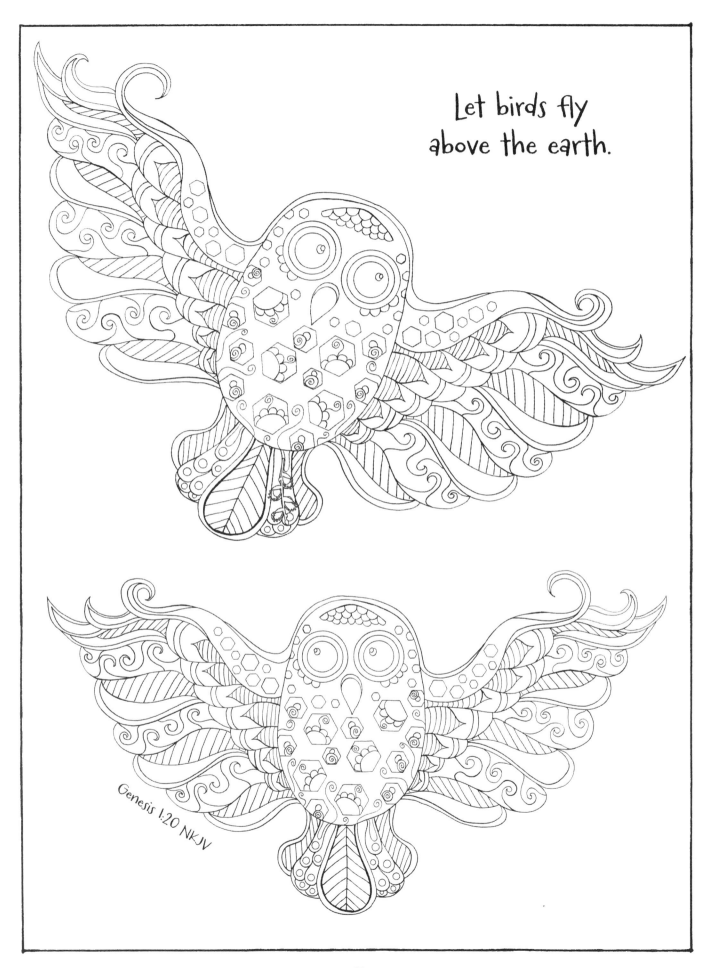

Let birds fly
above the earth.

Genesis 1:20 NKJV

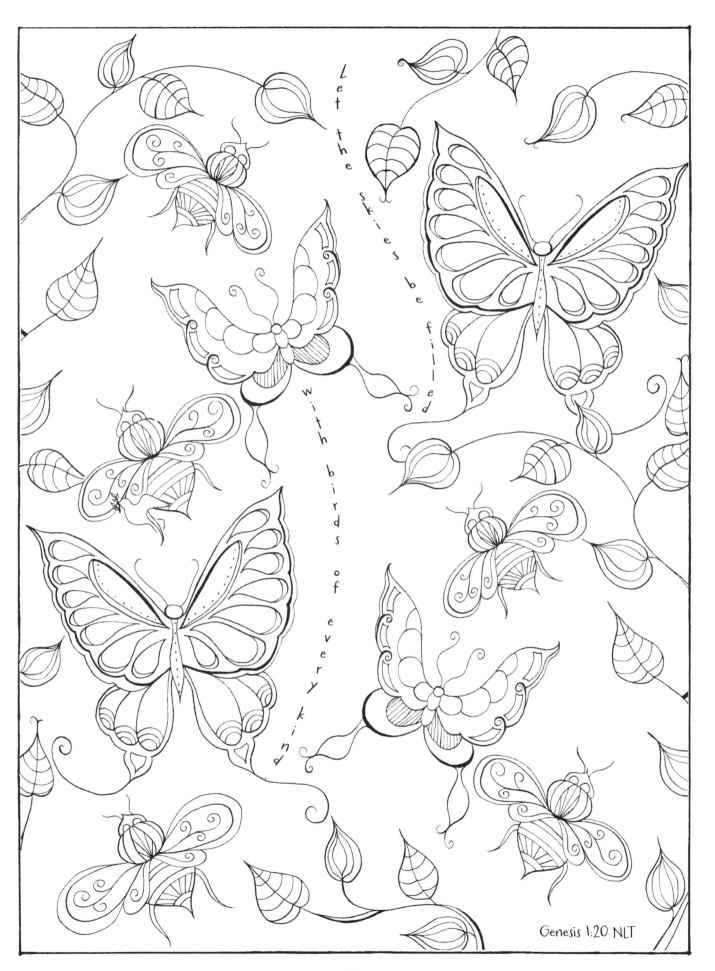

Let the skies be filled with birds of every kind

Genesis 1:20 NLT

every living thing that scurries and swarms in the water

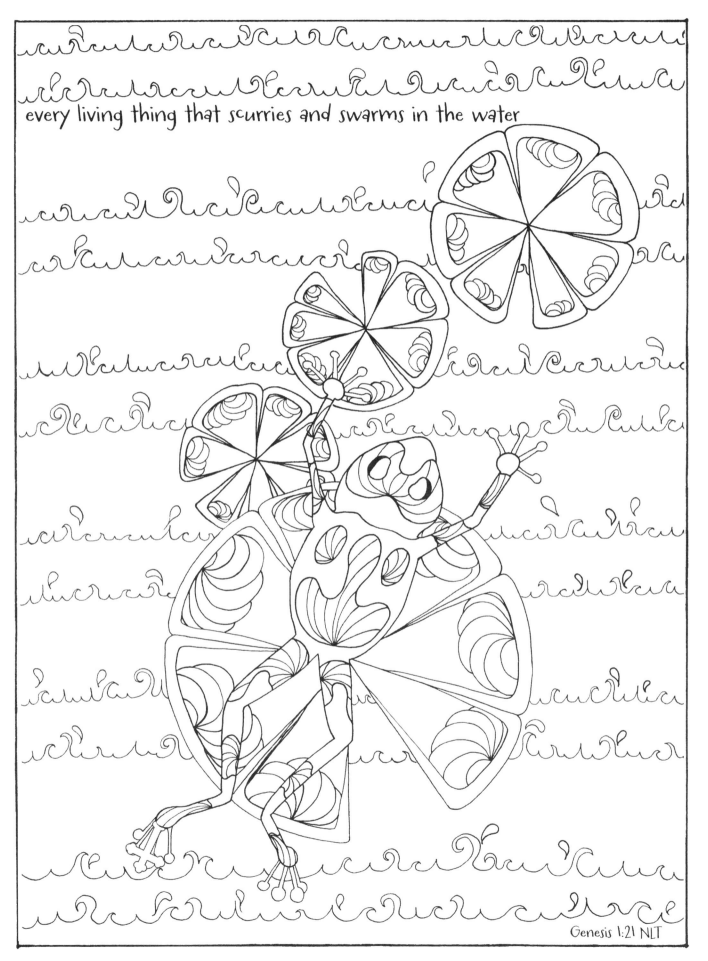

Genesis 1:21 NLT

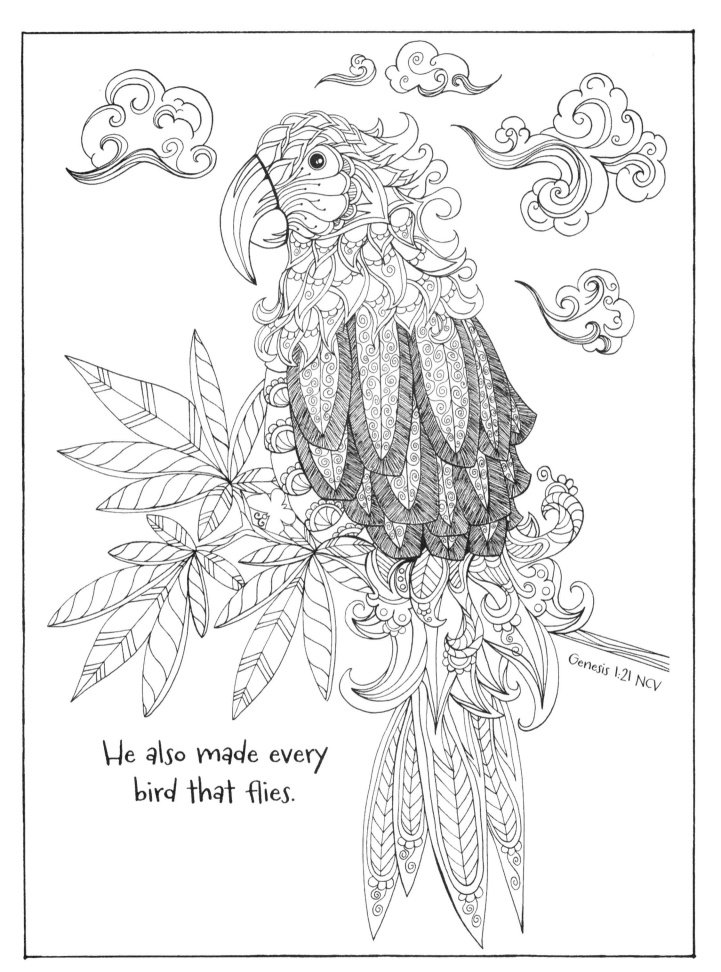

He also made every
bird that flies.

Genesis 1:21 NCV

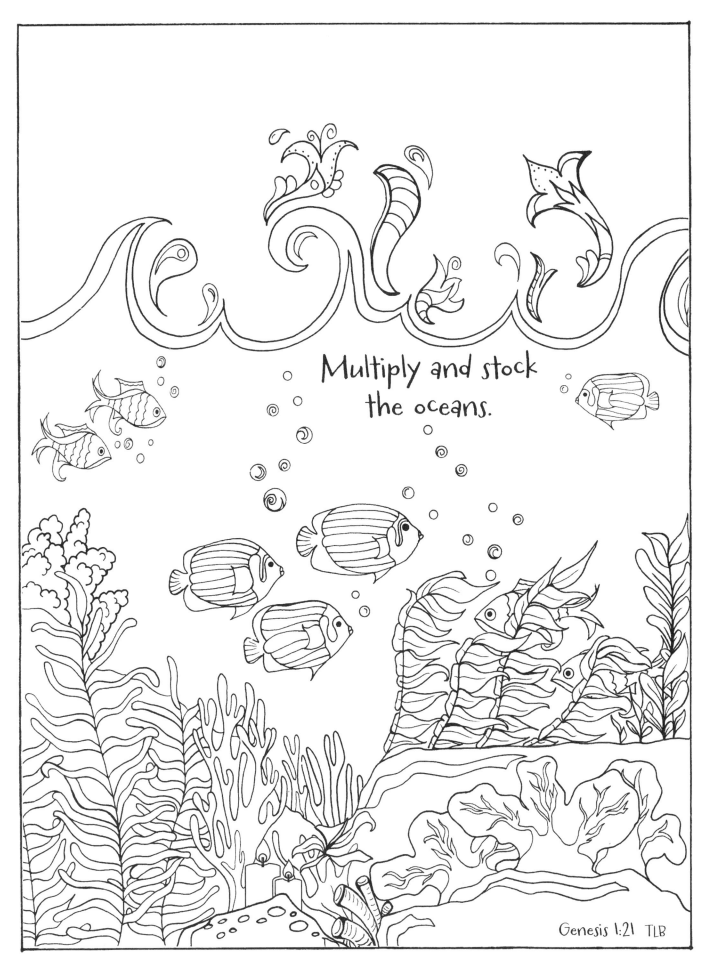

Multiply and stock
the oceans.

Genesis 1:21 TLB

God created the great sea creatures.

Genesis 1:21 NLT

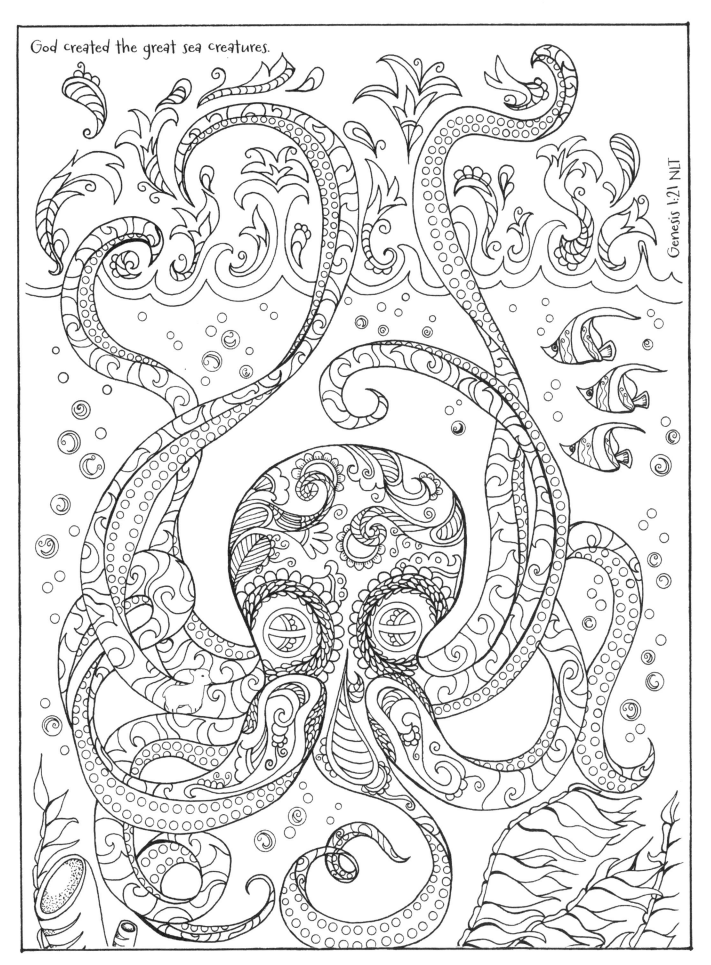

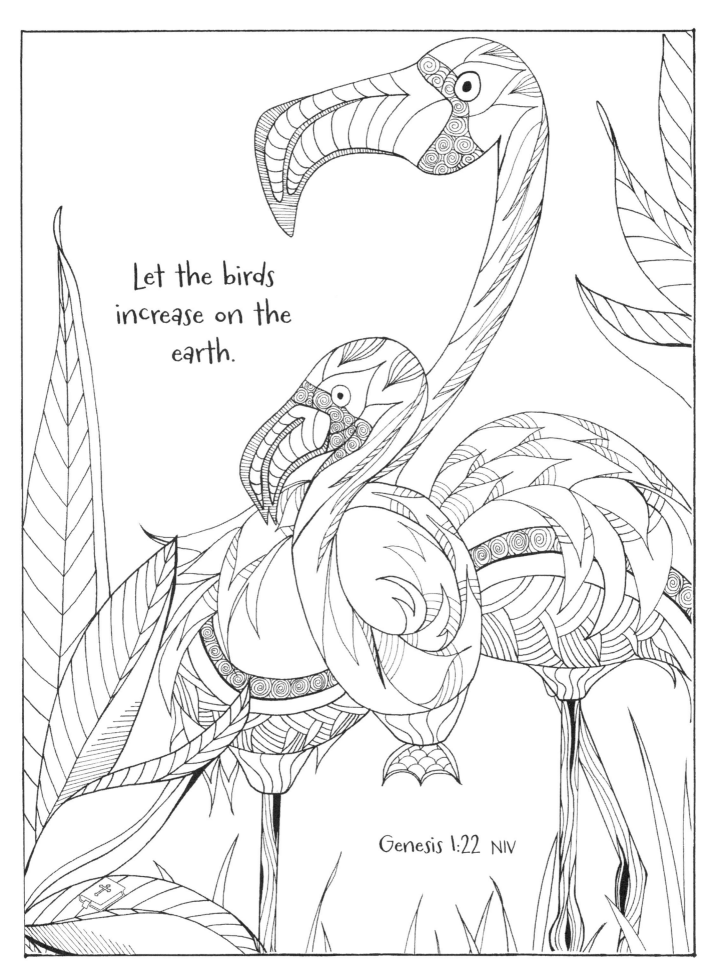

Let the birds increase on the earth.

Genesis 1:22 NIV

Let the fish fill the seas.

Genesis 1:22 NLT

61

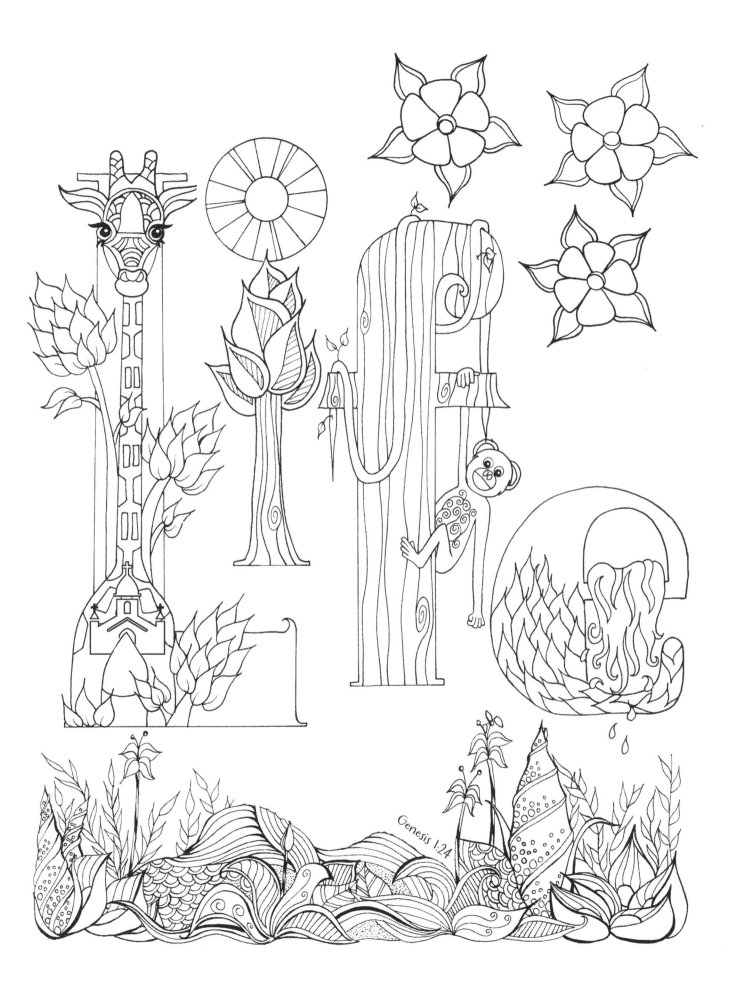

Genesis 1:24

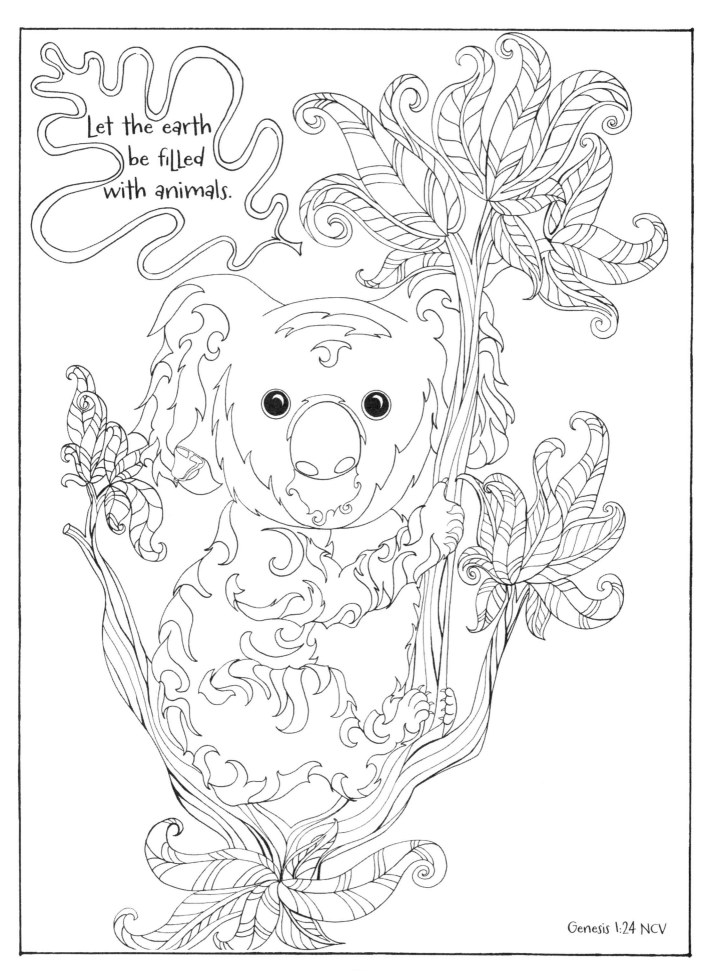

Let the earth
be filled
with animals.

Genesis 1:24 NCV

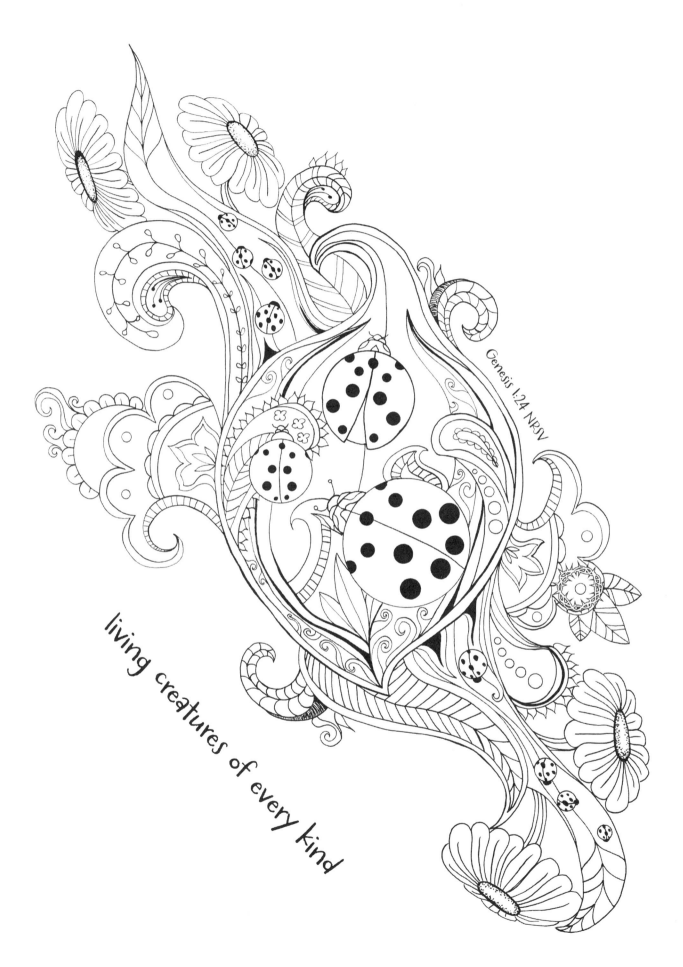

living creatures of every kind

Genesis 1:24 NRSV

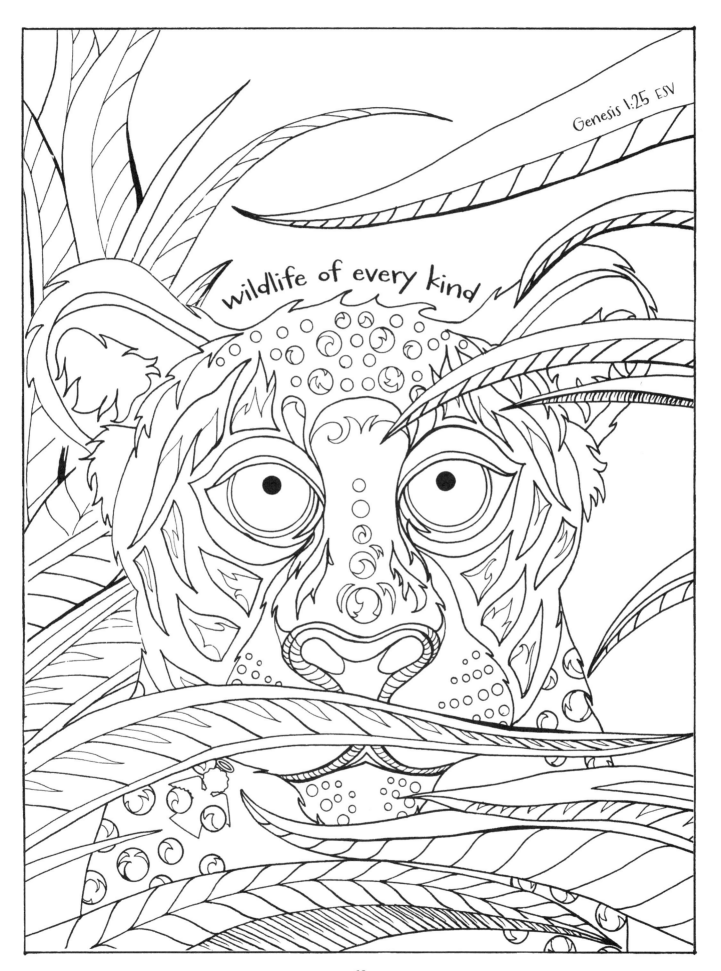

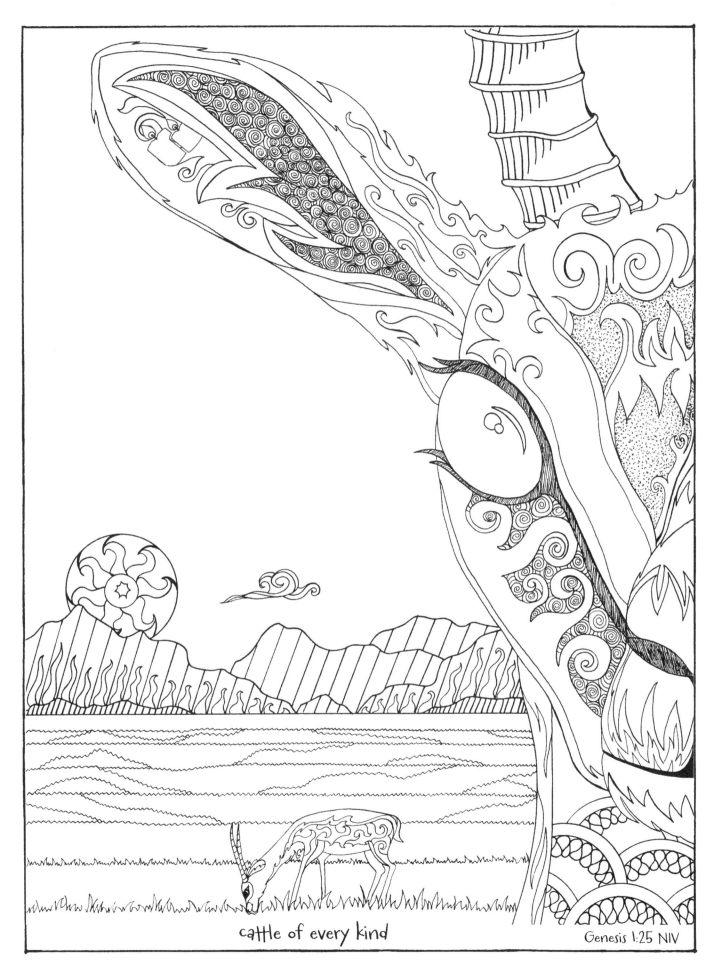

cattle of every kind

Genesis 1:25 NIV

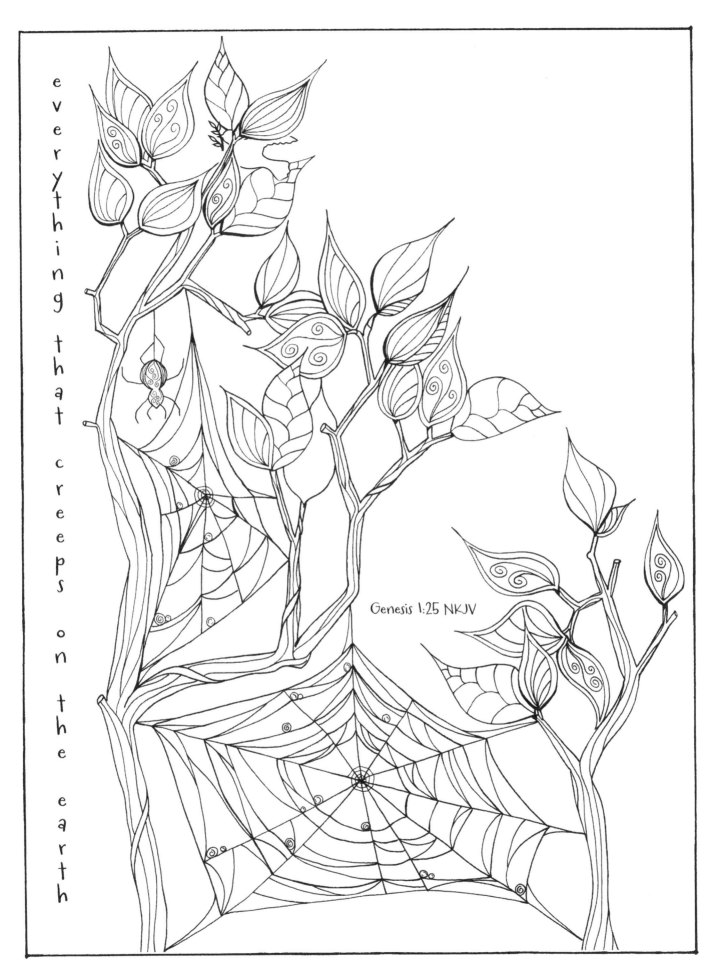

everything that creeps on the earth

Genesis 1:25 NKJV

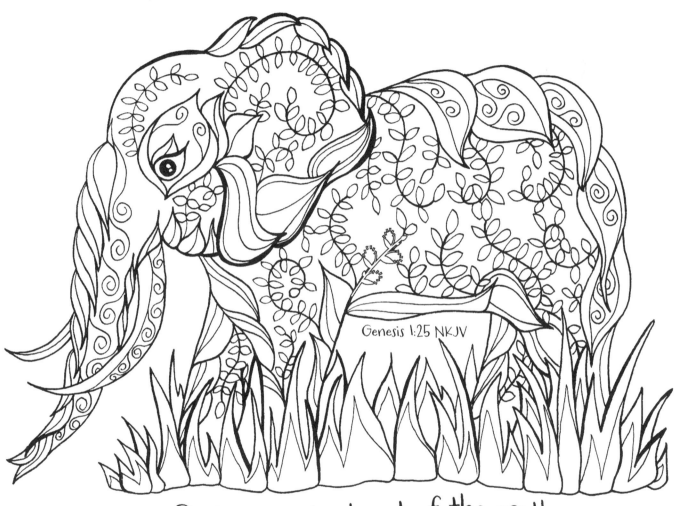

Genesis 1:25 NKJV

God made the beast of the earth.

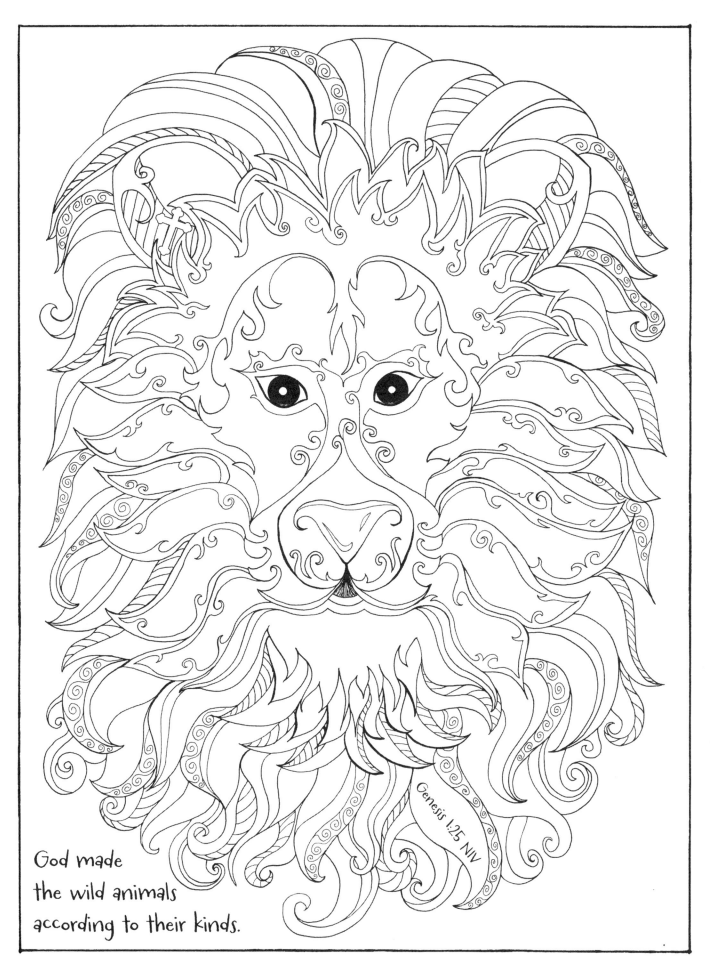

God made
the wild animals
according to their kinds.

Genesis 1:25 NIV

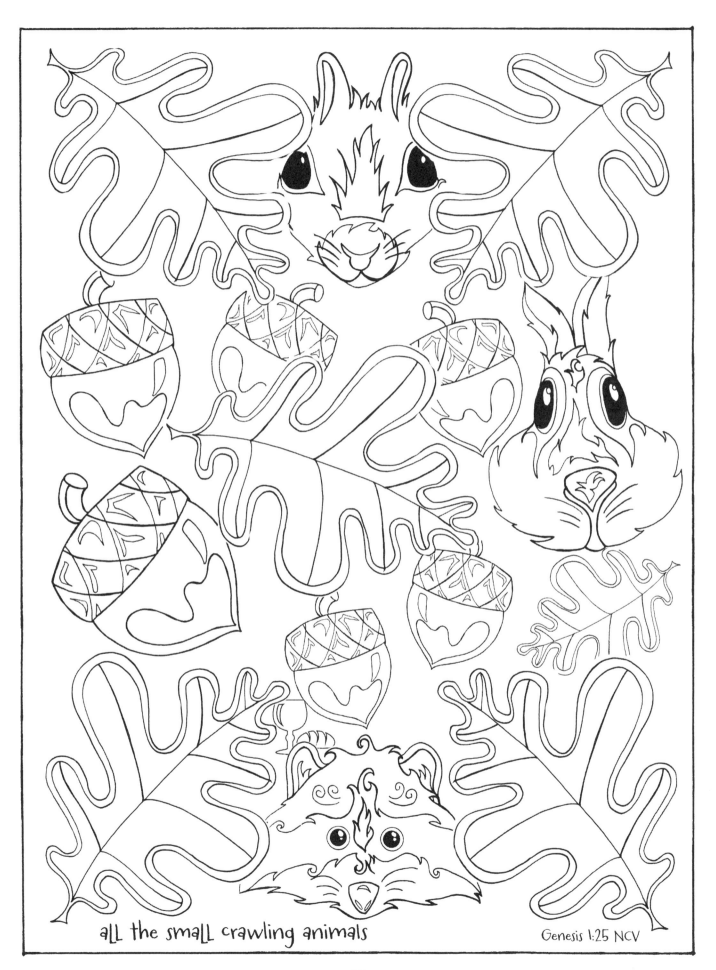

all the small crawling animals

Genesis 1:25 NCV

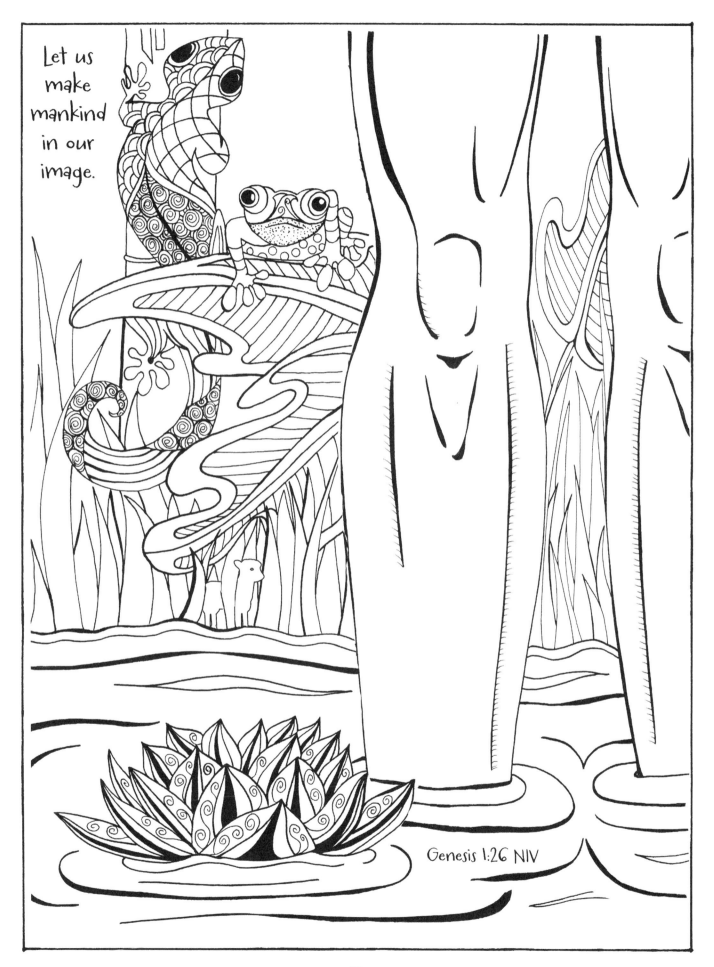

Let us make mankind in our image.

Genesis 1:26 NIV

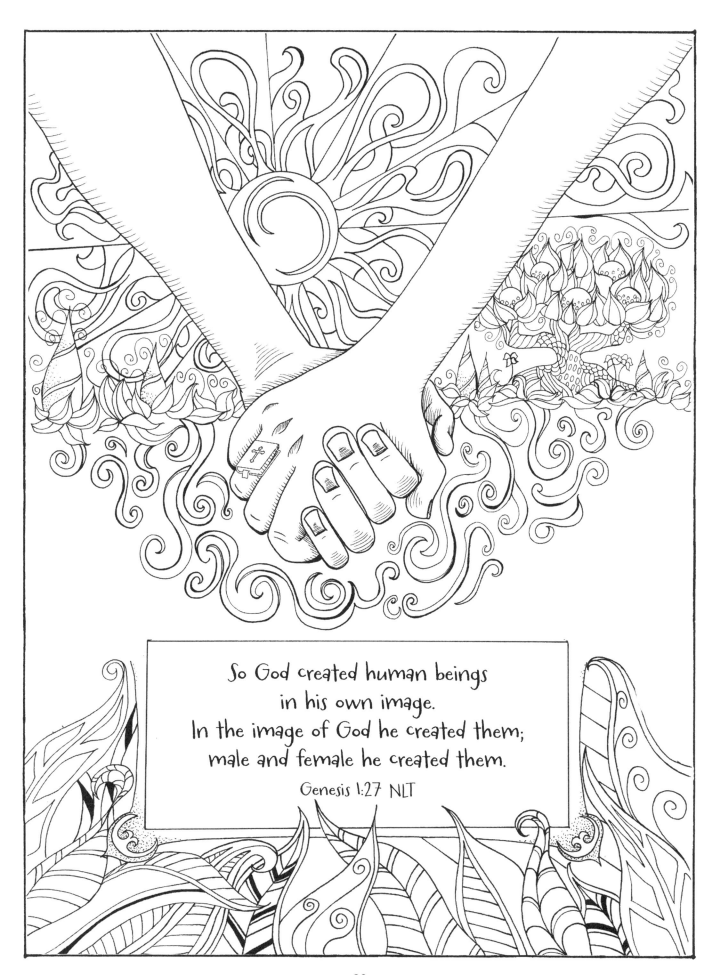

So God created human beings
in his own image.
In the image of God he created them;
male and female he created them.

Genesis 1:27 NLT

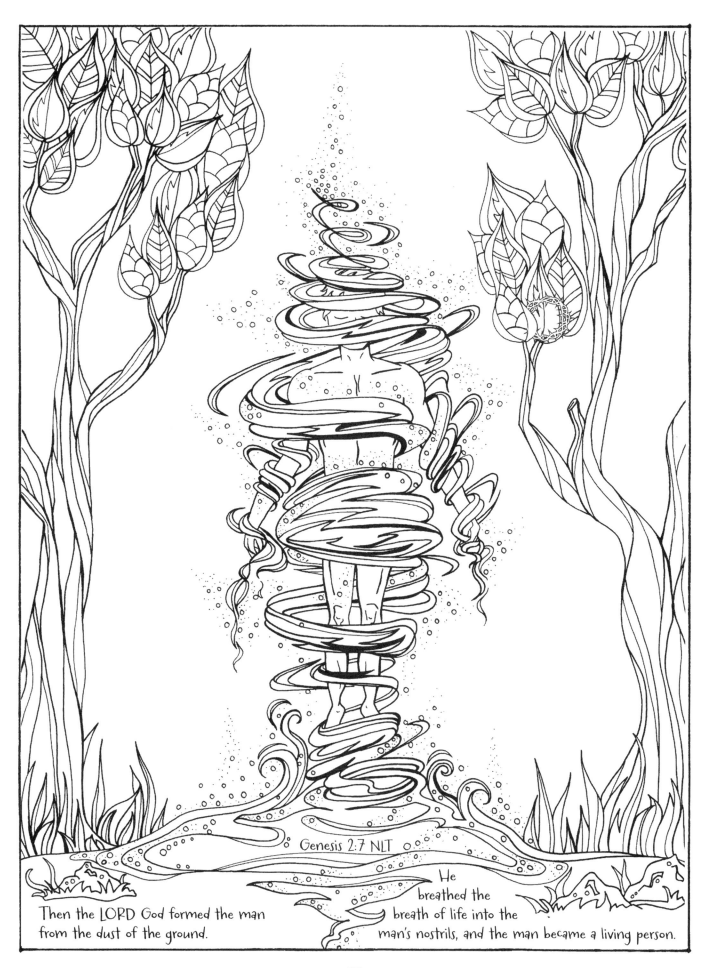

Genesis 2:7 NLT

Then the LORD God formed the man from the dust of the ground.

He breathed the breath of life into the man's nostrils, and the man became a living person.

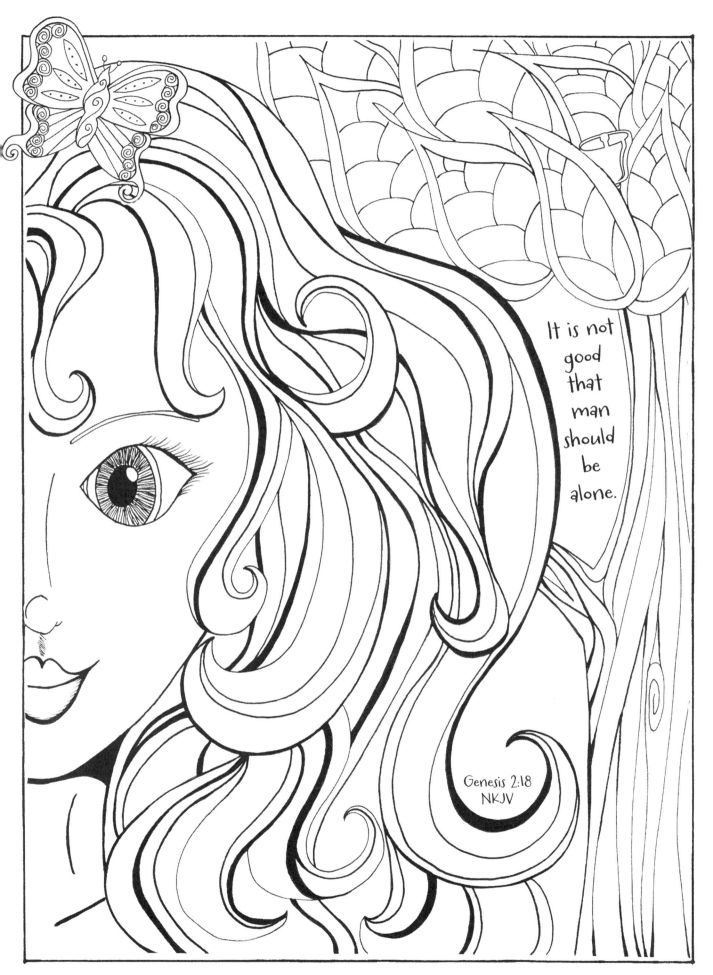

It is not good that man should be alone.

Genesis 2:18
NKJV

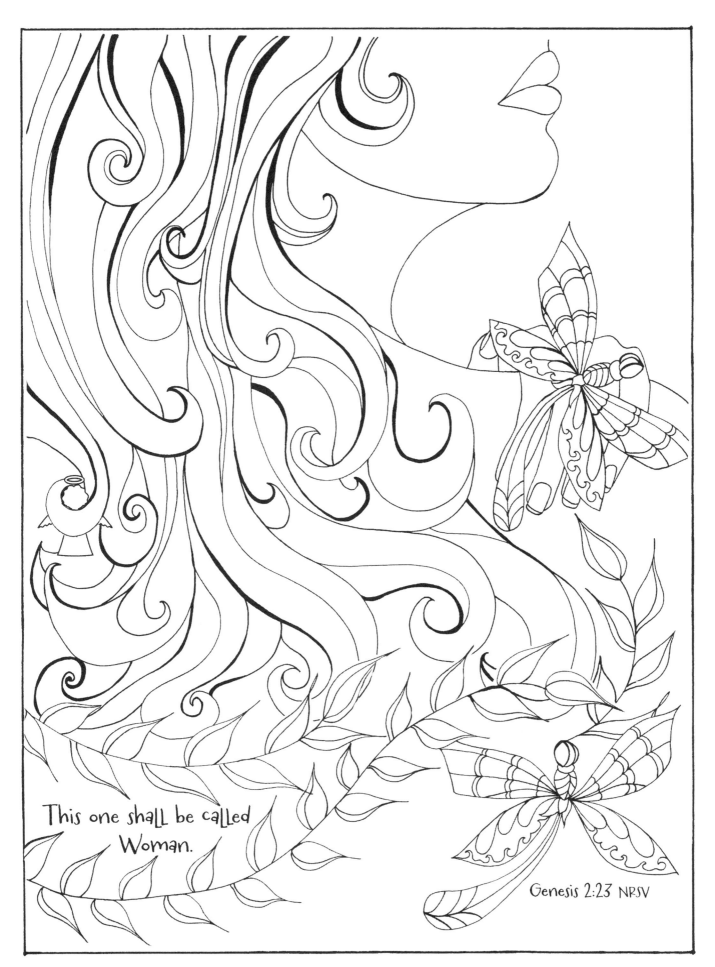

This one shall be called Woman.

Genesis 2:23 NRSV

God looked at everything he had made, and it was very

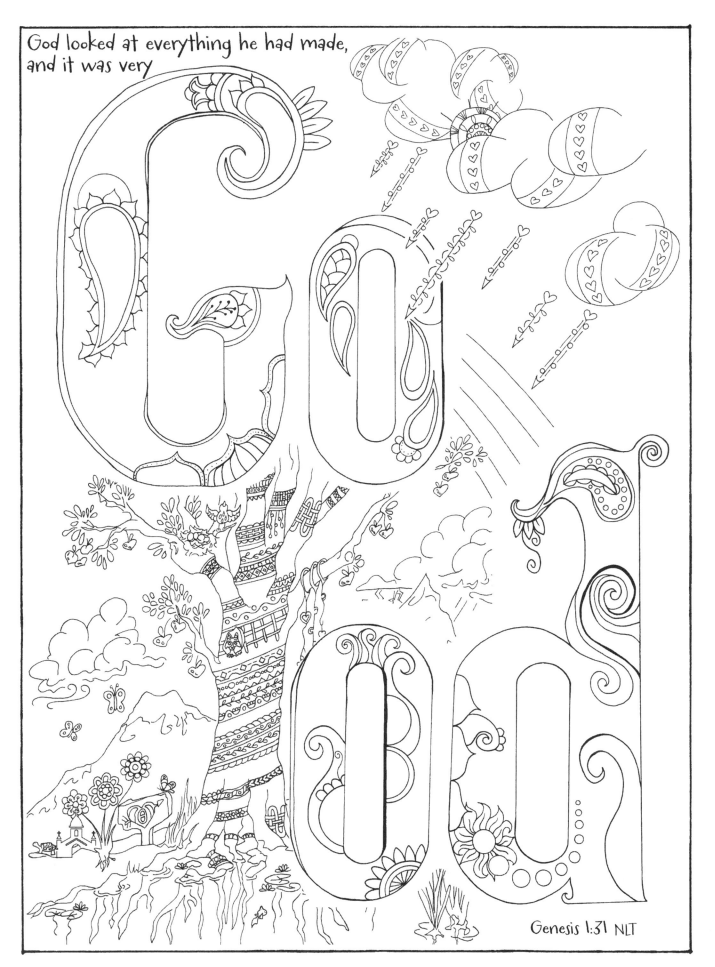

Genesis 1:31 NLT

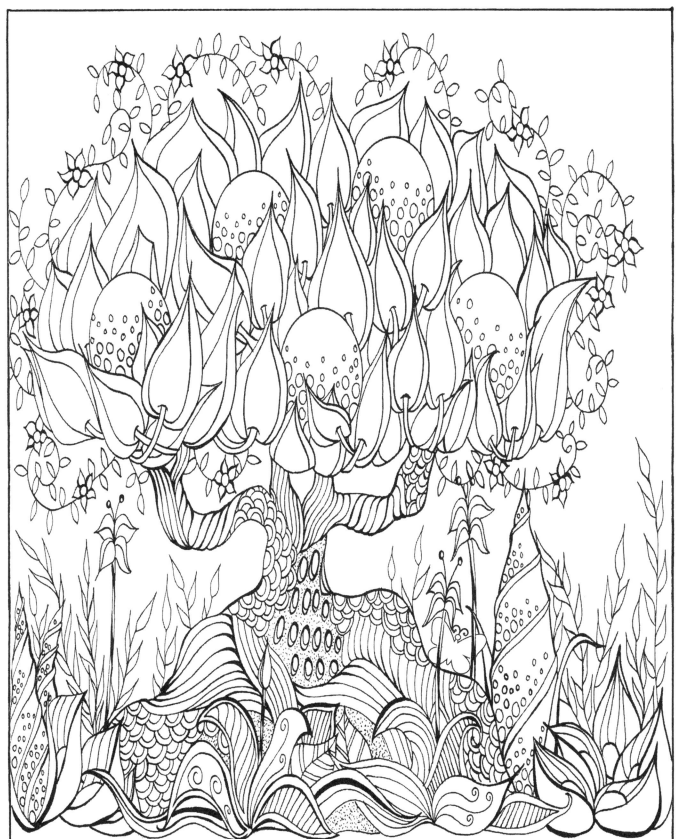

Look, I have given you all the plants that have grain for seeds and all the trees whose fruits have seeds in them. They will be food for you.

Genesis 1:29 NCV

Genesis 2:3